The
Photographer's
Choice

Luigi Cassinelli

The Photographer's Choice

Materia et Lumen

Naples, Florida

ISBN: 978-0-9861801-0-1
Library of Congress Control Number: 2015902812

This edition first published in paperback in the United States in 2015 by
Materia et Lumen
805 105th Avenue North
Naples, FL 34108
www.materiaetlumen.org

First Edition

A mia mamma

e

mio papà

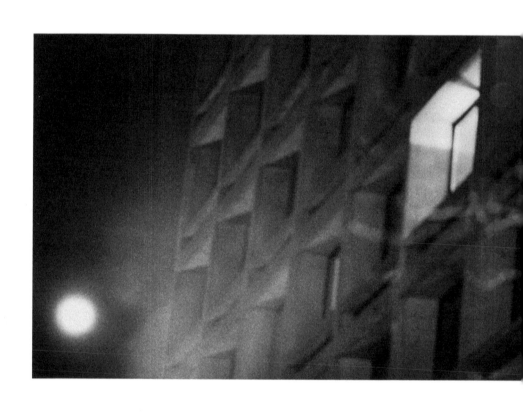

"I'm afraid!" said Zusha. "Because when I get to heaven, I know God's not going to ask me, 'Why weren't you more like Moses?' or 'Why weren't you more like King David?' But I'm afraid that God will ask, 'Zusha, why weren't you more like Zusha?' And then what will I say?!"

— from the Chassidic tradition

Contents

Introduction

"Photographs by Luigi Cassinelli." For eighteen years, this byline has always credited my fashion editorials, but recently, I realized that those words were misleading. Some of the images that were published under my name were not photographs, not even fair reproductions of photographs. They weren't sealed by light; they were the result of computer processing. Yearning for clarity, I wondered if this lack of semantic precision had been intentional. Why would an editor, you or I use the word photograph for two entirely different images; namely, the negatives seen here on the left and the images published in today's media?

Many more questions, regarding the essence of my work, started to puzzle me during a pivotal time of my life. My wife was pregnant and our hearts, minds, and senses were preparing for new responsibilities. Suddenly, life prompted in us endless questions, from birthing techniques to education principles. Months before the due date, we were already debating the pros and cons of several schools, in Europe and in the United States. This questioning wasn't confined to our familial cocoon. It was at this time that I admitted that my career as a professional photographer needed a fresh and critical review.

Behind simple questions, I felt the presence of a resolute, candid force. I wanted to be ready to answer questions like, "Dad, what is a photographer?" I began to see everything in a new way. Now, looking back on those months, I think of two new spirits, my daughter's and mine, growing and developing closely together. I guess she felt the same connection because she entered this world on my 49th birthday.

Joy and motivation were accompanied by unrest. In recent times, digital technologies had been offering endless possibilities to manipulate photographs. On the sets of fashion editorials and advertising campaigns, I was asked why I wasn't bringing computers, monitors, and technicians who specialized in digital imaging. While answering that those resources would only be a barrier to my photography, I observed that modifying my work appealed to my clients and the members of my crew. Sadly, I realized that, for some, retouching what I had seen through my lens was becoming more valuable than recording it.

Such a dramatic change in priorities challenged my purpose as a photographer in the industry. I feared that one

day I would be unable to find opportunities that honored my original passion for photography, while also satisfying my clients' requirements. Suddenly, I wondered if I had been pursuing discordant purposes during my whole career.

When a client demanded that I work only with digital cameras, I experienced a bold fracture with the industry. The apparent reason for such an ultimatum was that film processing was slowing down publishing lead times. I was at ease using digital cameras and processing software, but my new spirit rebelled against this despotic request. I felt this order was not entirely a power struggle between client and supplier in a competitive world. I suspected a threat was lying behind the widespread replacement of film cameras with digital cameras. Determined to expose the threat, I went back to my first days as a photographer.

Photography seduced me when I was already in my thirties. At that point, I had earned a Master of Science in Industrial Engineering from Politecnico di Milano, and I had been working in logistics and in the energy field. The decision to leave my engineering job, and to join the club of unemployed photographers, wasn't sudden; still, it was risky, based only on my intuition and on minimal experience. In 1995, I became a photographer by reading a light meter manual, cold-calling magazines and blindly submitting my portfolio. I never attended a course or assisted a master. I am self-taught.

In London, while I was waiting for agents and magazines to return my calls, I spent many hours in bookstores. There, I observed the work of photographers like Pat Booth, Bill Brandt, Robert Frank, Richard Gordon, Don McCullin, Helmut Newton, Ed Van der Elsken and Edward Weston, to name a few. Besides the genuineness and the clarity of

their work, I was charmed by the uniqueness of photography. In those books, I observed how light recorded what the photographers had seen, right in the moment when they had decided to let light record it. In their work, I saw more than composition, grain, contrast, graphic, style, fashion, horror, sadness, nudity, joy, and all the richness of details; those books displayed unique documents of each photographer's nature. I grasped that only photographs can document such an intimate bond among physical reality, observation, timing, and decision-making. It was then that I fell in love with photography.

Reviewing these memories raised a simple question; what motive could drive someone to mutate a photograph and change it into a product of imagination? Whose imagination? The photographer's? The art director's? The editor's? It doesn't matter. The result of the manipulation of a photograph is not a photograph, because it erases the honesty of the record. Any manipulation erases the intimate bond, sealed by light, that I discovered in London's bookstores.

A photograph's manipulation is itself a new object; it is the reproduction of an image that has been disconnected from its source—light, matter, the photographer, and the environment—and modified in pursuit of an intention. At times, behind photographs' manipulations, I sensed a superficial wish for a cosmetic remedy for the frankness of reality. In fact, from now on, I will name a photograph's manipulation a "wish-graph." Certainly, I shouldn't name it a photograph; otherwise, I create an impostor of the photograph and I manipulate my spectators.

From occasional conversations, I also began to suspect the

existence of photographers' impostors, that is, image-makers who were signing their work as photographers while publishing wish-graphs. At dinners, at art exhibitions, at the park, if I was asked about my job, all the fuss was about retouching, manipulating and imagining rather than seeing. I have heard comments like, "You are a photographer! That's fascinating. Can you make me look like a model?" "Which one is the best app for retouching my kids?" "Did you watch the news? They showed the complete retouching work that was done on a model. At the end of the retouching session, she was entirely different. This is crazy, she was already so beautiful, did she really need that?" These few examples, and many more, made me aware that the identity of the photographer was under attack from all sides. When possible, I replied with the following: "I can't make you look like someone else. What I can do is to photograph you with the same spirit I photograph each model." "Please, spare your children and yourself from retouching." "Do you think that we should divide people who need retouching from people who don't? If you do, you are a visual fanatic."

I was caught off guard by these questions and I felt my immediate answers were only scratching the surface of the issue. What I regret is that, at times, I published wish-graphs, too. For example, if a print showed a pimple on a face, I had the pimple removed before publishing. I used to consider this type of intervention an innocent touch, a gentlemanly one. Why not? Would the presence of a pimple make me a better photographer? Certainly not. A more rigorous photographer? Maybe, but my claim was that pimples come and

go, they don't influence the integrity of my records. I was wrong. Where is the borderline between the removal of a pimple and completely manipulating a photograph?

This question doesn't apply only to fashion and advertising. Retouching can be applied to any image and can serve any purpose; to add people to an empty party, to impose an African sky on a Siberian landscape, and to transform the expression of a child in tears into a child who is smiling. The list is infinite.

The heart of the matter is our relationship with reality and the assessment of the difference between observation and imagination, photographs and wish-graphs, and photographers and image-makers. If these differences aren't clearly defined, there is room for manipulation. When I think about the images that my daughter will see in the media, I see a source of danger. I will try my best to advise her how to learn from these images and not to be spoiled by them. Prior to that, it is important for her to distinguish among different types of images, for example the view of a real cat and the view of an imagined cat. Children are in danger when the difference between the words "real" and "realistic" is not clear.

Such ambiguity doesn't occur only in the realm of still images. With the usage of digital technology every image can be manipulated and blended together. For example, today's computer animation can be more realistic than an old documentary shot with black and white film. Right there, where the line between real light and realistic light fades, I see a threat.

Digital technology is not responsible for misinterpretations. Digital technology gives us opportunities and alternatives; human decisions are accountable for ambiguity. My

point is that there is nothing unethical in constructing images, according to our vision and our own imagination. What I find unethical is to name "photograph" what is not a photograph; the unethical decision is to create impostors and validate them.

For whom does it advance? I believe we should find clarity in ourselves, by questioning our nature and what drives us. So this is a precise question: which part of our nature creates and supports visual manipulations? I wrote this book to share my questions and what I have learned from photography.

Now, let me take you to the origin of a photograph, the instant where light, matter, and the photographer connect, and to the origin of a wish-graph, when light, matter, and the photographer disconnect.

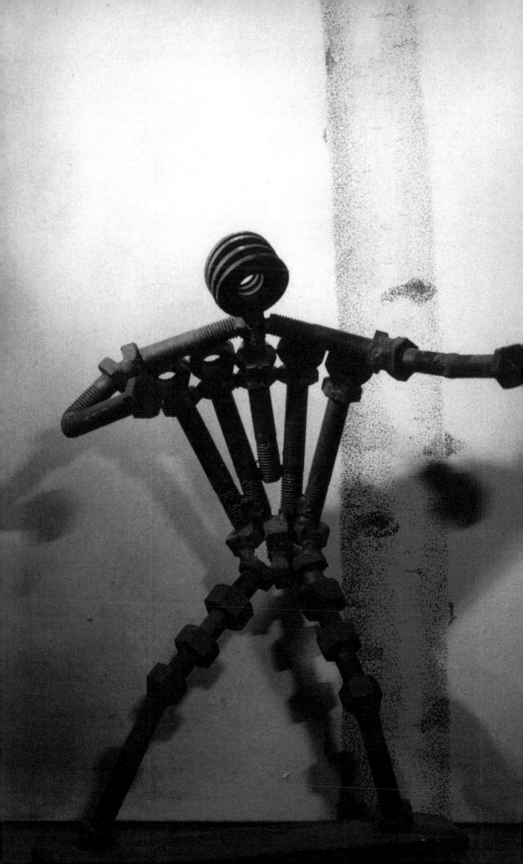

Part One

An Empirical Analysis
of Photography

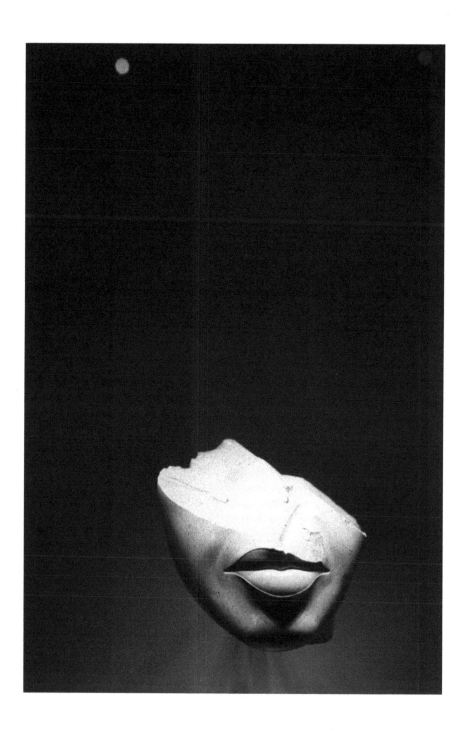

I

Intimate Dates and Virtual Simulations: The Difference between Photographs and Wish-graphs

Starting from the etymology of the word, I can state that a photograph is a document created by the photographer and recorded by light.* Though, to get to the core of this matter, I need to be more specific. Often photographs are explained as a camera's product. This association is not only trivial, it undermines the essence of photography. The "camera obscura" (dark chamber) has been helping architects, engineers, painters and other talents for more than two thousand years. Such help is vital, since our sense of sight is crucial in our quest for knowledge. Our sight is fast and perceives space in three dimensions. It changes focus, perspective and attention in a

* From the *Chambers Dictionary of Etymology*: "n. 1839, formed from English *photo-* light + *-graph* instrument for recording."

fraction of a second. Any glimpse can be recalled, or get lost in our brain. No surprise that the most eclectic "Renaissance Man," Leonardo da Vinci, was trying to study optics using a camera. But, his camera couldn't record anything.

Photographs derive from the discovery of the interaction between light and matter. Thus, I must deduce the essence of photography by understanding how this interaction works and how it relates to human nature. Leonardo couldn't participate in the birth of this invention. Another two centuries had to pass before Johann Heinrich Schulze, a German physicist, discovered that certain silver salts are sensitive to light. Once exposed to light, "The combining element is liberated, leaving pure metallic silver which, because unpolished, is dark in tone," writes Beaumont Newhall, in *The History of Photography*.[†]

This first, pivotal step was followed by a series of inventions that culminated with the mass production of cellulose-based film of silver halide. After so many years of peeping through a box with an aperture, now the light forming the image projected on the back of the box could be recorded, becoming a material trace. The refinement of chemical technology wasn't achieved in one day. At the beginning, it took a very long time for the overall process to be completed. For this reason, it is quite understandable that the studio of a photographer in the second half of the nineteenth century was not that different from a painter's studio. Iron frames were necessary to keep the subject still. Outdoors, some photographers were already recording documents from the battlefields. Action was hard to record with the film and cameras available at that time, but

* See Leonardo da Vinci, *Codex Atlanticus*.

† Newhall, Beaumont. *The History of Photography*. New York: The Museum of Modern Art, 1978

there was an abundance of corpses to witness, along with the stiff pride of the survivors. Film technology took about one hundred years to develop into what I am still able to buy today for a few dollars: a roll or sheet of black and white film.

Let's think about what happens when you load a roll of film and start to photograph. I like to think of this process as an intimate date. First, you have to arrange the date. A date between film, the sensitive partner, and light. Not just any light, though. Light can be overwhelming; you need to explore, observe, wonder, and find out when the light is revealing rather than blinding. So use a black box (a camera obscura), with no distractions other than a black door. Through that door, at the right time, only that revealing light will be let in, and the date takes place. This black box is your camera and that date is your photograph. During the date, light and film form a new image. All the photons previously forming the image in the viewfinder of the camera and hitting your eyes now interact with the sensitive partner, the silver halide embedded in the film; this natural phenomenon is the genesis and the core of a photograph.

One more step is needed to develop the latent image into a photograph, this defines the next fundamental feature. In a final phase, with the help of different baths, the image will be revealed and fixed, in the form of positive or negative, becoming a completed photograph. If we look at it under the microscope we would be able to see millions of grains in the layer of cellulose. The characteristics of these grains, and the overall appearance of the photograph, are determined by light and the response of the film to light and to chemicals. At that point, the record is material and permanent. Of course we can tear the photograph, we can destroy it if we wish, but we cannot modify it.

Therefore, the complete definition of the word "photograph" is: an instantaneous, material and permanent, original trace of the light conveyed by an optical system. The term "original" refers to the real experience which creates the photograph, the instant where light, the photographer's interaction with his or her environment, and matter connect at the same time. The term "original" helps us to differentiate a photograph from its reproductions. For example, a gelatin silver print and duplicated negatives are not photographs; they are reproductions of photographs. Daguerreotypes, negatives, slides, and Polaroids are photographs; they have different characteristics, but they all are original traces of light. The term "trace" should be interpreted with its existential meaning: an indication of the existence of something (the metallic silver left in developed film is the physical trace of the direct action of the light reflected by the environment).

A camera doesn't make you a photographer. The camera is necessary to achieve photography, though, not sufficient. A photographer is an explorer who chooses to record his or her observations with light and matter, not with words, numbers, and symbols. A photographer is an explorer who decides to record his or her observations by means of photographs. The photographer chooses the optical system, the selection of light to be recorded, and the material characteristic of the photograph (the film format, the type of emulsion, and the developer).

Now, let's turn our focus to the definition of a wish-graph. If we repeat the same process described in the analogy of the date, using a solid state sensor instead of film, we lose the defined attributes, an original trace of light that is material

and permanent. Engineers will find this analogy quite crude but in simple terms the "sensitive partner" has been replaced by a wall of glass and a photocopy machine. Light, instead of meeting a partner and melting into it, thus creating a new physical object, now freezes on the glass in order to be measured. The sensor, the element I call the photocopy machine, is an analog to digital device connected to a computer. The sensor translates light into electric signals on every part of its surface and associates a number to each measure. Then, the camera computer stores the batch of numbers as a digital file, and discards the analog signal. At this point, contact with light is lost; all that is left is a numeric code.* Digital cameras deliver numbers, not matter.

Compared to a photograph, a numeric code has diametrically opposed attributes: it is immaterial and transient. The fact is that we must elaborate the numeric code to view an image (digital to analog). In order to do this, we need a computer simulation model.† The computer simulation model is software designed to mimic the appearance of photographic images for operating devices like monitors and printers. The software computes the numeric code by requesting us to input the features of our desired image. The software allows us to preview many different effects (for example, optical deformation, exposure, contrast, color, texture); then, we save our choice and view one image. If we change our mind, we can play again and simulate

* Usually called "raw file."

† Simulation is an engineering technique designed to refine decisional models. An example could be a 3D model that helps engineers to test the consequences of a flood on a building foundations. The simulation model is a tool to fine tune the project, because eventually it will be the building, not the model, to face the flood.

another image. If we don't want to play the simulation game, we can set the software to automatic mode. This is what the majority of people do. The digital images displayed by the monitor of a digital camera are visual simulations executed in automatic mode. In other words, all of these elaborations can be done intentionally by the image-maker, another person or by a computer, resulting in the ability to produce multiple visual simulations from the initial numeric code. In my experience, this is the part of the process that many people take for granted. A digital image is not an original.

That is not photography; it is not light and matter exhibiting what we recorded; it is a software translating, or anticipating, our desires. The term "digital photography" is utterly misleading; it is a contradiction of terms. Photographs are recorded by light and sensitive matter, in one, direct passage, the genesis of the photograph. By dividing the recording into two processes, an analog to digital one, and a digital to analog, digital cameras create a permanent fracture where the connection between observations and light is lost. The digital to analog process is entirely concocted, since there is complete discretion on how to process the numeric code in order to view an image. No physical trace is left. This process lacks the essence of photography, the most important attribute, the existential one. In this process, there is no need for the environment and the photographer to exist; only computers are necessary. The photographic interaction is now displaced by an arbitrary computer simulation model. Calling a numeric code a photograph is like claiming that we can fly with a flight simulator.

Which name should we give to the image processed and delivered by a digital camera? "Digital image" is not a precise term. All images displayed by monitors are digital ones; some render photographs, and some display fantasies. Also, terms like "image" and "picture" are generic. In fact, the journey of digital deceit began with semantic confusion. We can name the output of a digital camera "numeric visual simulations." But the point is: simulations of what? Of a real phenomenon? Of a fantasy? We can find terms with a deeper meaning if we ask ourselves deeper questions. What is the nature of the images a computer simulation model delivers? They are images disconnected from reality, because they are built only on numbers. Numbers are easy to store, to transfer, to display, but they don't prove contact between our mind and the rest of reality. They belong only to our mind, they don't exist anywhere else. When we look at the page of a magazine or at an image on the Web, we have no clue if what we see is linked to a real experience or even if the author of the image was there. I do not deprecate the value of digital cameras and of the numeric codes they deliver. By observing feedback from their digital instruments, scientists analyze numbers linked to real phenomena; for example digital cameras help doctors in operating rooms. Conversely, I am suspicious of numbers when, far from measures, they generate virtual reality, simulations of real experiences. Severed from empirical observation, a simulation model is a virtual game. I must ask myself, "What is the purpose of this game?" It is a desired reality. This is why I name these virtual visual simulations "wish-graphs."

Tables A-D will help to clarify my point.

TABLE A

In Table A, I have reproduced the content of
one of my photographs. Let's pretend that I
don't have the original negative and let's de-
scribe how the image of Table A could have
been produced by using digital cameras.

Table B shows how two numbers can be
the output of a simple digital camera. Such
a camera would measure a strong level of
light intensity in the upper part of its sensor
and a low level in the bottom part of it. By
associating the number 1 to strong light and
number 0 to darkness, we get a basic report of
the light conveyed to the sensor. Indeed, two
numbers can't display what we see in Table A.

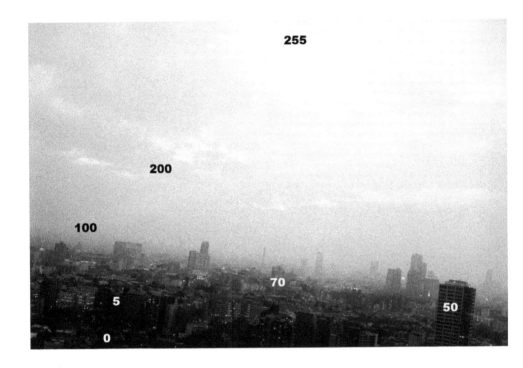

TABLE C

Table C shows that more numbers are needed to display Table A. Millions of numbers must contribute to create the detailed report which allows us to look at Table A. We need a digital camera that divides the sensor into more zones and uses, for example, 255 for white, 100 for medium grey, 50 for light grey, 5 for dark gray, and zero for black.

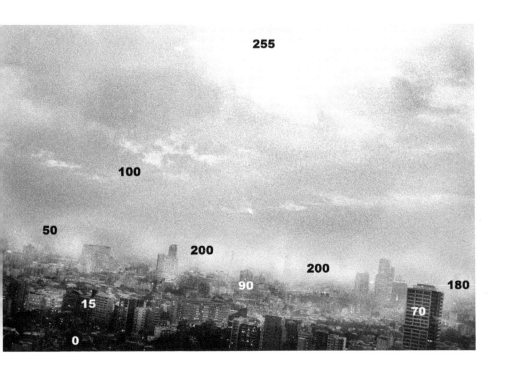

TABLE D

In Table D, just by changing a few numbers,
I transform the content of my photograph.

Table D is a wish-graph. Wish-graph is my definition for a digital image that has no contact with a physical trace. Lack of contact could have happened by manipulation of the content of a photograph (like in Table D) or it could simply occur because its numeric code is invented. From an existential point of view, a wish-graph is a document of no significance; a wish-graph cannot claim whether it delivers a visual report about an empirical experience or about a product of the imagination.

Digital cameras deliver numeric codes: reports of numbers which aim to build wish-graphs. A high resolution camera will deliver a highly detailed report about an experience; still, a detailed report is not a photograph. For example, had I not my negative, Table A would be a wish-graph too. A report's goal is the description of a memory or of an idea; it expresses nonfiction or fiction. I could claim that what I remember of the natural image I saw in my viewfinder is described by Table D. Besides my memory, Table D may express better than Table A what I feel about Tokyo or my idea of Tokyo. I could also show you a dinosaur emerging from the mist. I may add data by writing the longitude and latitude of my location. But I wouldn't be a photographer.

As a photographer, I respect and observe my photograph, the trace of light embedded in photographic film. For this reason, when I print, I try my best to be true to my photograph; I don't need to recall anything and I don't seek dramatic effects.

At this point, I can conclude that it is wrong to assume that digital cameras simply supersede film cameras. Film and solid state sensors offer us two alternatives, photo-

16

0101000101000101000010101000010101010010111100010100010100010100010100001010000101010010111000101000101010010101010010101010001010101001011111000101000100010101010010101010101010111100010100010001000101010010001010000101010100101111000101000101010000101010000010101000010101010010111110001010001000101010100010101000010101010010111100010100010000101010000101010100101111000101010001010100010001000101010010101010101010101010101010010111100010100010100010101010010100010101010010101010010111100010100010001000101010010100010100001010100010101000010101010010111100010100010101010010101010000101010100101110001010001000101010100010100010100001010100001010100001010101001011111000101000100010101010010101010010111110001010001010101010101010000101010001010100010101000010101010001010100001010101001011111000101000100010101010001010100010001010101001010100010101010010101010000101010000010101000010101010010111110001010001000101010010111100010100010001010101001010001010100010101010010101010000101010000010101010010111100001010001010101000101010000010101010010111110010100010100010001000101010010100010100001010100001010100010101000010101010001010101010010111100001010001010100010101000001010101010

TABLE E

graphs and wish-graphs. Thus, we face a choice. Which technique do we choose to record the natural image we see through our lens? I choose photographs because I trust the direct action of light. Light has no malice; light allows me to see. Then, a trace of light will be my document.* It took a long time to discover the correct materials to record light on matter; right when film technology is mature and reliable, I choose to hold on to it.

By choosing wish-graphs, we should ask ourselves why we prefer a numeric code to one trace of light. One click of a film camera creates one photograph; one click of a digital camera can generate countless virtual images. Following Table E, we can see that a numeric code is very precise, but it is designed to be processed and mutated. Nobody can prove that the image based on the first numeric code is linked to an original measure; nobody can

* I may be fooled by a mirage, and by the path of light from air to water, but only till I understand the natural phenomenon of refraction.

prove that the other codes are wish-graphs. In the virtual world, which one of the following files is the record of what I saw through my lens? It is not the raw file saved on the flash card, since it needs to be processed in order to be visualized. Is it the processed file that the camera computer sends to the monitor? Which monitor? The 3-inch camera monitor or the 24-inch one? Is it the processed file sent to the printer? The one saved by the retouching app? Each one of these is a wish-graph.

In the virtual world, the word "original" has no meaning. The paragon is stretched, however, if you think of Leonardo scanning the *Mona Lisa* and then burning it because the actual material work, the trace, his strokes of paint, are not important any longer. With digital technology he could do back-ups, variations, set up a factory, print many copies and become rich. But back-ups of what?

Why should we give up a trace, the result of a natural phenomenon? Do we want to give it up? The moment we choose to use digital cameras, we let go of the photographic experience and we choose to enter a virtual world. In the very least, we should never create impostors by using the word "photograph" for "wish-graph."

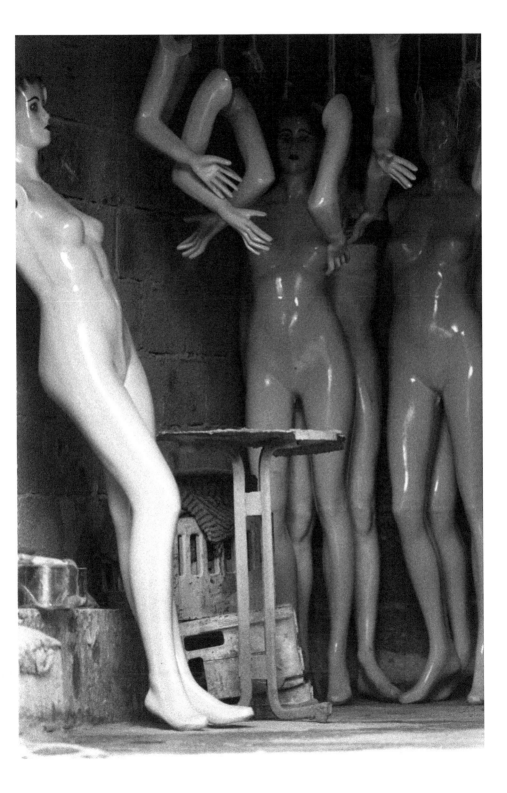

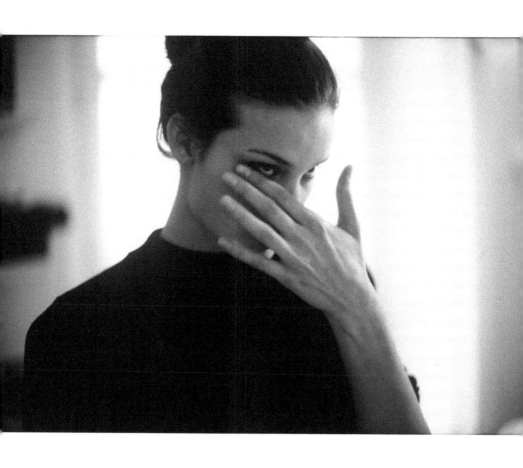

II

The Independent Instant

What type of experience do photographs offer? From the analysis of a photograph's origin and completion, the intimate date analogy, it emerged that during the short time between the opening and the closing of the camera shutter, the silver elements quickly react to light. The use of the word "short" is vague, but I would say the process is short enough to be protected by human control; it usually lasts from fractions of a second to a few minutes. Such an interval raises the issue of time and of timing. It influences the overall dynamic process of the date.

Unlike works that rely, from start to finish, on human control, such as a novel or a painting, a photograph has a specific dynamic, a final instant that is independent from us. The critical instant is the one when the shutter is released, after

that the content of our photograph is sealed by light. Prior to this, there is only preparation. Then, in the instant of the click, a shock. After the shock, all the work is in the hands of chemistry, which can only influence contrast and grain. The content as it was seen cannot be changed. This dynamic is very challenging; the entire process revolves between cycles of preparation and instantaneous decisions. Each frame is one cycle—one photograph. There is no going back. Independence and irreversibility constitute the essence of photography.

Photography is an existential experience that takes place within uncut reality. By "uncut reality," I refer to the interaction between my whole identity—my instinct, my soul, my intellectual framework, my emotions, my senses, my conduct—and my environment. My photograph, the document of such a complex experience, is recorded by the light reflected by my environment; hence, I can photograph only my environment. Plainly stated, photography needs me to work with two partners, light and the environment I am facing.

We cannot photograph our ideas or our emotions, only something physical that triggers a response in us. Unlike writing, photography can't rely only on our own imagination and past experiences. We can imagine our ideal love, or a love in our past, or the one that we will meet, but we can only photograph the one in front of us. A single photograph is not an expression of an idea. A single photograph is neither a piece of fiction, nor a piece of nonfiction—a recall of an image; it is a direct emanation of uncut reality.

Once the basic condition of photography is clear, the first decision of a photographer is to choose between static partners, like artificial light and inanimate objects, and dynamic partners, like natural light and animated beings. Other decisions will determine the optical system's angle, the type of film, and the selection of the environment that will be recorded. All these decisions can be understood as a period of preparation. Indeed, the core of the photographer's preparation is not in planning decisions; it is in the photographer's identity, in his or her honesty, sensibility, and values. These qualities will drive the final decision, the time to record. Independent partners will only emphasize the unique dynamic of photography, the irreversibility of its last decision.

I find photography a unique and inestimable experience because the inseparable connection with a dynamic environment demands a priority in our decisions; a single photograph may reveal clues of how we prepare to work with our partners and of how we react to them. Photography offers two opportunities, an opportunity to test our intentions, and to expose how our complex nature interacts with our environment.

My point is that decision making can't be either entirely planned, or replaced by an automatic snapping camera. We can spend days preparing and designing a photograph; conversely, we may load our cameras with a lot of film and mimic a machine gun, but facing an independent environment means accepting being able to face one decision at the time.

Now, imagine a battle field where a photographer is a witness to two dramas happening at the same time. On

one side, a soldier is killing an unarmed enemy; on the other side, another soldier is risking his life to save a wounded enemy. What would you do? Would you photograph? What would you photograph? When? What would you listen to? To your idea of war? To your emotions? To the most spectacular scene? Would you listen to your soul? If someone asked me these questions, I couldn't answer; I could find true answers only in a little frame of exposed and fixed negative film. I can truly decide in a real situation, not in a virtual game.

What I can tell you is that photography is my adventure, not a planned storyboard; my camera is my spaceship, and my photographs are the result of my explorations. I am curious to interact with a real environment; only in a following phase, the editing, will I acknowledge my findings. Preparation should support me, it shouldn't trap me.

Photography can't be re-created or copied. Even when it looks dull, a photograph is always authentic, original, and intimate. A single photograph is a record from real life, where time is a fact and the adjective "timeless" is an illusionist's trap. If we insist on going back to one particular location, we will never be able to replicate photographs. If we are so desperate and scared that we only manage to photograph a controlled environment, everyday, under the same light in our cellar, then either we really need help or we must have very specific reasons. Just realize we will only be seizing a fraction of the potential of photography, rather than experiencing the full extent of its opportunities. A series of photographs is not an effort to stop time, but a way to understand its tempo.

Deciding has never been very popular. It reminds us to

accept that in life there are no stop and rewind buttons; our freedom can only find its way through decisions. Photography is an experience of freedom. We can't photograph the whole environment in the same instant, so we should be prepared to choose. Once again, putting our environment in a cage would only be an act of repression, hindering our freedom. In order to choose to be free from noise, we must be honest and be ourselves by listening to our innate, unique nature. If the interaction with our environment is mutual, then the result will be a document about human freedom.

This is the heart of the matter, where the motive and the results of the photographer must be tested relentlessly. Given the same environment, a bigoted mind will deliver photographs with poor content. A richer document will come from a mind that aims to achieve control. The richest, from a mind that is open to an exchange and confident in the exercise of freedom. Introspection, the exploration of our minds, needs feedback and reiteration within reality, it is a necessary practice in any empirical quest.

Can I read my own identity in my photographs? I believe so; though, it takes time. In this field, there is no place for immediate gratification. Think about the experience of a hunt, while I explore I gather information, but at the same time I also leave traces. Traces of my nature will always be part of my photographs, even if they have different degrees of intensity and genuineness.

Foremost, photography challenges the honesty of the photographer; only in a second phase does it connect with the eyes of the spectators. I believe that in our photographs we can

see traces of our experiences, ideas, sensibilities, and, hopefully, of our souls. The difficulty, innate in this field of inquiry, is that there is no quantitative measure of the results. We depend entirely on honesty. This shouldn't be seen as a limit, rather as an intense challenge.

By choosing to photograph I acknowledge that I need to make contact with another nature to reveal my own. This contact, materialized in a photograph, is a disclosing document. It may be so revealing (of both the photographer and of the environment), that other parts of human nature may try to compromise it; before or after the click.

30

III

Visual Fanaticism and the Retouching Urge

"Comrade, you must let your hair grow longer." This is my earliest recollection of visual fanaticism. The summer of 1976 was already over when I started my first year of high school in Milan. While I was waiting at the tram stop, dense fog was warding off my early attempts at orientation. In the cold hours before classes, crowds of students from all neighborhoods were crossing the city; we were grey figures floating in a grey urban landscape. One student left a small group; gradually he became visible through the mist. He had long hair and a scarf covered his face except for his eyes. From his confidence, I guessed he was a senior. His remark about my hair sounded automatic. He didn't wait for my reply and went back to his group.

My untroubled years were over, I was a rookie who needed

to grasp quickly the rules of a game played by student factions. In the seventies, in Italian high schools and universities, politics was the most popular game, more violent than soccer.

A constellation of political groups was confronting the Italian state and fighting each other. Every group was looking for attention; the majority of them pursued only formal rebellions, like spraying political symbols on every wall, wearing only specific clothes and accessories, shouting slogans in mass demonstrations. Luckily, most of them were only acting as revolutionaries; in spite of their political fever, they rarely missed mommy's pasta.

Others, maniacal criminals, decided to kill. Terrorists, invoking the rightness of their political dogma and the utter necessity of their actions, put bombs in train stations, ambushed and shot dead in cold blood hundreds of people, and smashed teen-agers' skulls. In April 1973, in Rome, a group of maniacs set a house on fire; a young man and a child couldn't escape and burned alive.[*]

An issue regarding hair's length is trivial when compared to the terror that befell Italy during the seventies. Nevertheless, it is important to highlight that fanatical obedience to an ideology leads to the uncritical acceptance of its visual norms.

Later on, when I again met the student who had warned me about my hair length, I found out he was only a year older than I and that we were attending the same classes. Emanuele claimed to be a rebel to any authority and to be a fighter for freedom. He couldn't stand short hair because it reminded him of his nemeses: his father, neo-fascists, the military service, Nixon, banks and multinational executives.

[*] See the documentary by Giovanni Minoli, *La Storia Siamo Noi – Morire di Politica*, RAI.

I told him that I had met people who actually found my hair too long for their standards, that their remarks had upset me as much as his, and that I found both comments just attempts to intimidate. If his pursuit of freedom had been true, then, he shouldn't have tried to impose any particular length to anybody's hair. Among people who believe in freedom of choice, hair length should be a personal preference, not the stubborn point of a child who pursues exactly the opposite of his father's expectations. I told him he was worshiping icons instead of fighting for freedom. He looked at me with a serious face, and told me that I was worse than a fascist; however, I was excused because I was a rookie. Then, he showed a charming smile and told me that girls were very sensitive to the rebel look. Finally, we were talking sensible matters.

He was a harmless guy, but my dreams of brilliant high-school experiences faded away at once; given the political situation, I was about to face extreme ideologies. To defend myself, I needed to understand their ultimate purpose.

Ideological dogmatism pursues the imposition of an idea onto reality. Ideological tyrants seek the complete domination of reality and abhor any independent nature, anything or anyone who questions their idea. When reality suggests that their idea could be absurd, they manipulate reality; tyrants force reality to fit into their idea in contempt of truth. For example, this was the basic principle behind the Inquisition's use of torture: the heretic must confess he is a sinner and that the dogma is the only truth, before he dies. Ideological followers disregard the tyrant's actions and, by doing so, support his ideology.

"Visual fanaticism" is the name I will give to the imposition of an aesthetic idea, by manipulation or by denial, onto physical reality. The history of astronomy gives us a clear example of how ideological and visual fanaticism are intertwined. Until Copernicus, and a few others, suggested a new model of the solar system, the whole intelligentsia had been worshiping a celestial model where the Sun revolved around the Earth. Such a model of reality was very simple to sell, to explain, and to visualize. It was deceitfully entertaining, like any egocentric desire, and it took a while to wake up from ignorance. When Galileo challenged the anthropocentric idea, all fanatics—religious, political, intellectual, and visual ones—put him on trial.

Visual fanatics refuse to see knowledge as the exploration of reality using a combination of intuitions and deductions from observations. Visual fanatics worship only the intuitive process that leads them to their model of reality, an aesthetic idea. Without checking their model's relevance to reality, they declare that knowledge and freedom are reached only by complying to their model. Any independent signal, showing a discrepancy between their model and reality, is not treated as an opportunity to question their dogma; on the contrary, it is ignored or acknowledged as an enemy.

Apart from the tragedy of terrorism, I have met people who, with eyes watering from fanatical, ideological fervor, and claiming to be part of the true avant-garde, tried to convince me that a mountain is just a bunch of rocks and that a triangle is what I should see and worship. On these occasions, I find it very difficult not to be overwhelmed by fear.

The problem for visual fanatics is that no matter how frustrated they get by reality, they cannot simply remove it. Nevertheless, visual fanatics convince themselves and others that reality is actually trapping human freedom, that reality should be avoided at all costs, and that the only way to be free is to imagine and to generate ideas without confronting reality. Visual fanatics' propaganda will fail to warn us that imagination alone, without observation and the responsibility of decisions, only opens the road to permanent denial of reality. Denial is a potent part of our nature that has no remorse for falling in love with the most complicated stories or absurdities, and is dazed, is confused, and even exhibits contempt in front of evidence. In a few words, visual fanaticism's imposition on reality occurs by manipulation and denial of reality. How do visual fanatics consider photography? As a menace.

As a professional photographer, I have noticed visual fanaticism in the decisions of corporations' officials, media gurus, designers, fashion editors, advertisers, art directors, image-makers and consumers. But I have also met people in these professions who encouraged me with their integrity and freedom. For example, in the fashion industry, I have met professionals who enjoy dictating trends to consumers and others who enjoy inspiring people. I am convinced photography is a menace to visual fanatics because a photograph is a crucial trace of light, an emanation from uncut reality. A photograph seals a momentous independent link between physical reality and the photographer's nature. A photograph doesn't give multiple versions of how the photographer related to his or her environment.

Such a document is a nemesis for visual fanatics because their dream is to manipulate reality according to their own or someone else's design. They fear any independent link within uncut reality, for it might ignite critical thinking and freedom, the end for any pursuit of domination.

In recent times, photographs have been displaced by wish-graphs to impose aesthetic ideas on human bodies. By comparing a set of prints from the mid twentieth century with a set from today's media, we can observe that human skin has been manipulated into a new material. Models, tennis players, actors, and anchor women share the same skin. Retouching affects all human features, from details like wrinkles to overall proportions. Conveniently, the words "photographs by" haven't been replaced by "wish-graphs by." I have been told that retouching is necessary to create perfect images, perfect products, and perfect examples of men and women.

The question is, perfect for whom? What is perfection? A world where all women share the same skin and fit a specific size? Uniforms? The shape of a 1970 Porsche 917? Your child's smile? Love? None of the above. Perfection is an idea. It should refer only to a lack of fault in the realm of logic. For example, we can say that a triangle is perfection, but it doesn't exist in physical nature. It exists in our mind, because our rationality is able to build the geometrical model that helps us to draw a mountain. But a triangle is not a mountain. When we stretch the mountain into three lines, we see that our ability to imagine a perfect model kills the immensity and power of the mountain.

Once again, the tool of modeling shouldn't replace the

reality we are facing. An abstract model should serve knowledge, not the other way around. Further, we should be very careful about the context in which we use the term "perfect." A perfect relationship is a must in mathematics. On the contrary, "perfect" has a sinister meaning elsewhere, often a despotic one. In the physical world, "Just perfect!" is the exclamation we use to justify an emotion, given by the appearance of a piece of work, of a person, or of an animal, that meets our idea of it. It is an egocentric (anthropocentric) way to affirm that the essence of something is in the idea we have of it. When we look at wish-graphs we shouldn't acknowledge perfection; a wish-graph is just the digitally processed expression of an aesthetic idea.

By displacing photographs with wish-graphs, visual fanatics kill two birds with one stone. The message they want to sell us is cheaper to produce and more effective. At the last minute, does the boss like the model's smile but not her eyes? No problem, keep the smile and paste on a pair of eyes that pleases the boss. If her body is not up to par with the one the boss thinks women should have, a custom body can quickly be arranged.

Photographers, those who try to see something unique in each model, are no longer needed. They don't solve problems anymore, on the contrary, they stand in the way of the desired result. They are superfluous. They reduce the pace. Further, they don't obey promptly the way software does. Who needs the photographer, someone interested in seeing rather than imagining, when post-processing creates the desired perfection, just by playing with numbers?

Realistic sells more than real, because people look at what is displayed on magazines, billboards, banners, as if they were photographs. They worship faces and bodies on magazine covers and that becomes their newest challenge to happiness. Intentionally or not, they ignore that those faces and bodies exist only in the mind of a marketing strategist.

The press and the advertising industry should disclose when they publish reproductions of photographs and when they publish wish-graphs.

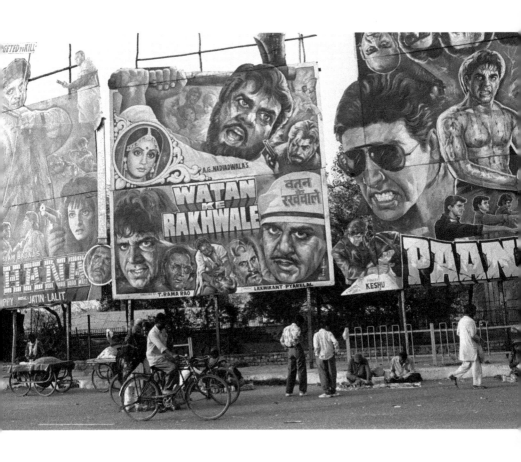

IV

Supporting Impostors

Professional manipulators are not the only ones who welcome the collapse of the use of photographic film. Right now, we are all responsible for the end of photography. The disappearance of film* has nothing to do with allegedly expensive and complicated processing. Digital imaging can also demand a frequent financial commitment due to fast obsolescence of its products. User-friendly features are not the issue either. It is true that a file from a digital camera can be quickly uploaded on our favorite blog, but a frame of film can also be easily scanned and ready for the same purpose. It appears to me that there is a plan at work, an urge to erase something important

* The photographs reproduced in this book were executed, between 1995 and 2013, with five different type of emulsions. Today, only two of those emulsions are still available.

and uncomfortable, something like Pinocchio's cricket. Photographic film is neglected precisely because it is the only reliable tool that records what a photographer has seen; film is the necessary condition to establish a direct link within uncut reality. What puzzles me is the speed with which film is vanishing. A roll of film and a digital sensor aren't just different technologies, they are poles apart. What is happening is similar to a case of stolen identity. Imagine parents who get rid of a child they don't like, only to replace him with an impostor, a robot that looks like him and has the same name. This is what is happening here. The extent of such denial is what frightens me and has motivated me to understand more about the reasons behind such behavior.

By calling photograph a wish-graph, we create an impostor. But this is not the only source of deception in the history of photography. To my surprise, even photographers, collectors, and museum curators who deal with photographic prints often call them photographs. This lack of precision is not marginal. On the contrary, it casts a shadow on the intrinsic value of photographs. Indeed, only film originals, negatives or positives, are photographs, anything else is a copy or a byproduct. Only film originals exhibit what the photographer saw in his or her viewfinder and what light and matter recorded. Reproductions of photographs, from silver gelatin prints to digital images for the Web, can be loyal or, by an act of manipulation, disloyal to their original.

Even photographic printing leaves room for the interpretation of a photograph. By projecting photographs, using the artificial light of an enlarger and sensitive paper, photographic prints will display most of the original's con-

tent.* For example by using a different quality of paper, we can change the contrast of a print. The manipulation of a photograph's content can only be achieved by spraying chemicals on paper, usually with airbrushes. This is one way retouching was executed long before the advent of computer processing. A disloyal print can also be created by working on the original film, once again with the help of chemicals. But this method would permanently damage the photograph and leave a physical scar. These retouching techniques have helped celebrities, dictators' propaganda, museum curators, photo-journalists, and ambivalent photographers. The embarrassing truth is that many of us still call disloyal prints "photographs."

At stake here is the hidden, fanatical imposition of an artificial intervention on a natural phenomenon. Calling a print a photograph is a small but fundamental step that paves the road to selling photography as a visual expression and hiding its existential nature.

Another critical mistake, one which burdened photography with misplaced expectations, is the belief that a photograph is a copy, or a reproduction, of reality. Such a belief indicates an idea of reality based on static entities. A photograph is not a copy of our sight, nor of reality; it is the result of an interaction which takes place within reality. This interaction, ignited by the photographer, has to take into account the dynamic of the environment, the film chemistry, and the specific angle of the optical system—the lens. It would be a mistake to confuse a photograph with the simulation of our

* A print cannot exhibit the whole photograph's content. Some information is lost in the reproduction process.

sight. Our sight is dynamic and perceives color. The perspective of a lens is static. When we look at each other's faces, we usually don't set ourselves in a frozen confrontation at a fixed distance, through the angle of a wide, normal, or telephoto lens. Wider or narrower angles affect the perspective of the record, not its existential value. A photograph that reveals a portrait is not a copy of a face; it is the document of an original interaction; no more, no less.

At this point, I would like to make a distinction between aesthetic idealism and visual fanaticism. Examples of the perception, the idealization, and the loathing of reality are shown in the history of art, philosophy, and other human enterprises. An extreme example is surrealism, a total rebellion against reality. Although the rebellion of surrealist artists was a shout, not a lie. An artist may cut a photograph into pieces, for example to express his or her contempt for reality, but an artist who manipulates is a fanatic, not a passionate idealist. The frank modification of a photograph may be proposed as a piece of art; the covert manipulation of photography is an act of visual fanaticism.

For all that, we shouldn't underestimate the difficulty in telling a story with photographs without betraying the honesty of the photographs. Visionaries and storytellers have tried hard to apply their intentions, their effects, their meanings to photographs. With the help of other techniques, such as collage, color, text, projection, editing, and sound, a series of artists, politicians, advertisers, cinematographers, journalists, and illustrators have used the photographic invention to sell their stories. By adding a simple title to a photograph, we stick a concept into something that is an emanation of uncut reality. It is quite hard to add to a photograph,

because a photograph is a complete document of a real interaction, and it doesn't bend to interpretations.*

The literature on photography is crowded with debates about the alleged ambiguity of certain famous photographic prints (sadly, all the authors I read, use the words *print* and *photograph* synonymously). Is he shot by a bullet? Is he pretending to be shot? Is he shooting a real bullet in the prisoner's head? There are endless examples. It is pointless to ask a print, even one loyal to its original photograph, to tell us the complete version of a story. Let's ask the one who is telling the story, the storyteller. I would be happy to know that what is published on the media is a loyal reproduction of what the photographer saw in his or her viewfinder. If photographers and journalists arrange staged shootings, we may debate about their motives and their nature. Photography is never ambiguous; storytellers and audiences may be. Often, we understand what we want to understand and we see what we want to see; despite what light and matter recorded.

Supporting an impostor is just one of the many decisions, of a technical and ethical nature, involved in the craft of visual story telling. Let's examine the moment when we observe our environment by means of our cameras. Choosing a monitor over the viewfinder of the camera reveals diametrically opposed purposes and leads to disparate consequences.

* Throughout this book, I placed reproductions of my photographs. I didn't title them; nonetheless, just by placing them in between specific parts of my story, I am using photographs to suggest thoughts, to underline passages, and to exhibit my photographic work. As a storyteller, I printed my photographs to support my story. As a photographer, I scanned my photographs in order to get reproductions that could exhibit as much as possible of the content of my negatives. I didn't apply any modification; I adjusted contrast to fit book printing specifications.

Both monitors and lenses (a viewfinder is made of lenses) are filters we place between our eyes and our environment. They convey two different images. Monitors show computer simulations; lenses convey to our eyes the same light we experience. A recent trend is to carry, everywhere, flat screens that can host handy devices like phones and digital cameras. Those cameras can produce computer simulations like machine guns shoot bullets, flooding our attention and our time with massive data and wish-graphs. I have been told this is progress. This so-called progress suggests one scenario to me.

Soon, we will have electronic eyes everywhere. We will all share the most repulsive virtual intimacies. It will happen when monitors, with phones and cameras, are available at a microscopic level. Then a large part of humanity will mutate into zombies with cybernetic eyes. The signal of such a desperate era will be the advertising of a unique micro-chip; the campaign will claim that by installing it in our body, our decaying eyes will get cybernetic power.

At first, to gather respectability, the product will hit a medical market. In a second phase, other campaigns will promote cool features for everyone. The product will deliver plenty of fun and control of our own sight. For example, we will be able to program the cybernetic eyes to erase anything we don't like from our sight, from little details to big nuisances. The cybernetic eyes will also be able to automatically mutate the appearance of whatever we face into something or someone we desire; just imagine and the computer will do the hard work.

Sounds interesting, doesn't it? After all, we will be able to switch back to our own sight. But, why should we? The experience will feel absolutely natural; furthermore, there won't be any heavy monitors to carry around and the micro-chip will automatically download updates from the internet. I bet, in a third phase, a tyrant will install cybernetic eyes into newborns with the purpose of erasing envy from this world and achieving peace. I can anticipate the propaganda: "We all have the right to the perfect desire!"

Such a nightmare is not far off; indeed, this is exactly what my clients asked me to do. By banning film cameras, they don't want me to look through a viewfinder, to observe how light reflects on a real person. Instead, they want me to look at a monitor, the most spectacular filter between mankind and the rest of reality.

V

The Photographer's Choice

All men by nature desire to know. An indication
of this is the delight we take in our senses; for
even apart from their usefulness they are loved
for themselves; and above all others the sense of
sight. For not only with a view to action, but even
when we are not going to do anything, we pre-
fer seeing (one might say) to everything else. The
reason is that this, most of all the senses, makes
us know and brings to light many differences be-
tween things. —Aristotle, *Metaphysics*
 translated by Sir W. D. Ross

Photography has almost disappeared; the link among light,
matter, human experience, and sight is being manipulated
and replaced by wish-graphs. I am writing this book to re-
mind fellow photographers that we have a choice and that we
are all accountable for the impending consequences.

As a matter of fact, rejecting the value of digital cameras in our lives is an act of denial; for example, digital cameras help surgeons in operating rooms as much as they help a dad experience a real time chat with his daughter across an ocean. Film cameras can't achieve such tasks. That being said, there is no reason for photographers to relinquish the essence of photography, their unique connection with light. I believe that he who trades a photograph for visual simulations of it cannot call himself a photographer.

For thousands of years we waited for a visual document, a permanent trace of light linked to human nature, an emanation of reality. How can we discard it simply because it doesn't want to play our game? It doesn't make sense to me. This is exactly why photographers need film. We are explorers, not virtual dreamers. Photographers observe reality and decide to record traces of light; scientists and visual fanatics are the ones who pile up data and look at monitors. What do they observe in those monitors? Scientists observe electronic measures; visual fanatics choose to worship virtual reality and opt for alienation. I don't see any progress in virtual reality. Instead, I see fellow humans who stand a few yards away from each other, don't look at each other, but claim to photograph each other while staring at computer simulations of photographs.

As I see it, the way we are using digital imaging is creating barriers between our sense of sight and light. Solid state sensors, monitors, software, computers, tethers, and numbers take away the point of photography. These barriers eliminate the essence and the intimacy of the photographic experience; they take away our experience with light.

In this book, I pointed to visual fanaticism as the part of our nature that is responsible for photography's disappearance. Alarmingly, the sinister threat that lies beneath visual fanaticism reaches beyond photography's end. Based on my experience, anytime we worship aesthetic ideas and hold reality in contempt, we create our own cage and give up freedom. The result is alienation. Alienation, the separation from reality, could be rooted in fear and in traumas. What we witness in reality may be unbearable for our souls; however, we don't recover from our scars by replacing raw light with sophisticated flat screens. We won't heal by adding insult to injury. But alienation can be a conceptual choice. It is the choice of someone who divides reality into many sealed compartments under the rule of the human mind, a sort of intellectual *divide et impera*. This is a fanatical choice; it is an intellectual war against the complexity of reality. During this epic war, fanatics who worship the supremacy of conceptual methodology have created superstitions to replace observation with imagination, drugs to manipulate our minds and our senses, and decoys to divert our souls.

Homer foresaw our times and warned us against alienation when he narrated the encounter of Ulysses and Circe. Circe's magic is a drug that mutates humans into alien creatures. This is the world adored by visual fanatics. What they want to see and what they intend to do replaces what they see or what they do. How do they justify this? By glorifying any conceptual tool; for example by glorifying numbers.

Virtual reality's postulation is the idea that reality can be replaced by numbers, a condescending fanatical superstition. According to such an idea, the complexity of reality can be

translated and, conveniently, manipulated by numbers alone. Contemporary manipulators realize that old legends have lost their grip on mankind; now, they sell a high-tech illusion, a virtual universe dominated by computers and built on monitors.

The monitors' plague couldn't exist without the synergy between intellectual fanatics and visual fanatics. Thirty years ago, when my friends and I attended computer science courses, it seemed inconceivable to be unable to pull the plug of our machines. We were wrong. Someone found the way to produce an unstoppable flood of numeric codes. I can't rejoice because an instinctive yawn is my sincere reaction to any massive display of numbers. I ignore how many times a day the average person looks at an image on a monitor. I have never met Mr. or Mrs. Average. I hope I won't. I hope my daughter won't either. I don't need any data to realize what is around me. It is enough to observe children and see how docile their eyes become when illuminated by flat screens.

Those following the trend ask why should they respect light? What can light reveal? Why rely on light when they can be in control? Forget about uncut reality, the click and the moment, and tiring decisions: post-processing is the future. They don't want to see, to find, to explore a better world, they are happier by just imagining one. Post-processing is a better reality. They can be whoever they want, even better, they can create whatever they want. Here the totalitarian dream resurfaces by handing the power of numbers to visual fanatics' imagination; what a couple.

My hope with this book is to give photographers re-

newed enthusiasm. My hope is that it serves as a wake-up call from the narcotic effect of virtual reality and it reminds us that words and numbers are useless ideas when dissociated from the rest of reality. Digital technology is designed to compute numbers, to store them and to copy them; at all times, we should remember that numbers exist solely in our minds.

Despite our efforts to create sophisticated conceptual models and to see the world as an imperfect version of our abstractions, we are still struggling to learn from reality undivided, to achieve freedom and justice, to understand the gap between our intentions and our conduct, and to respect nature. In Delphi, on the *pronaos* of the Temple of Apollo, our forefathers carved in stone a salient reminder that starts us on a path to wisdom: Know Yourself.

I believe this reminder can save us from alienation when we choose freedom over fanaticism. Thus, we shouldn't set arrogant prejudiced priorities; we should be humble and learn from experiences where all our resources contribute: our instincts, our souls, our rationality, our emotions, our senses, and nature. We are not above reality; we are part of reality. Photography reminds us of that. Photography reminds us that freedom needs interaction, and light is photographers' fundamental link with their environment. Our mind alone, with all its rational and creative power, can't save us from alienation and it can't get us very far in the quest for knowledge. The astronauts who explored space and the moon didn't face only numeric codes; they didn't challenge their courage with conceptual discipline. Their achievements can't be measured by numbers. They found in their spirit, rationality, emotions, senses, and in

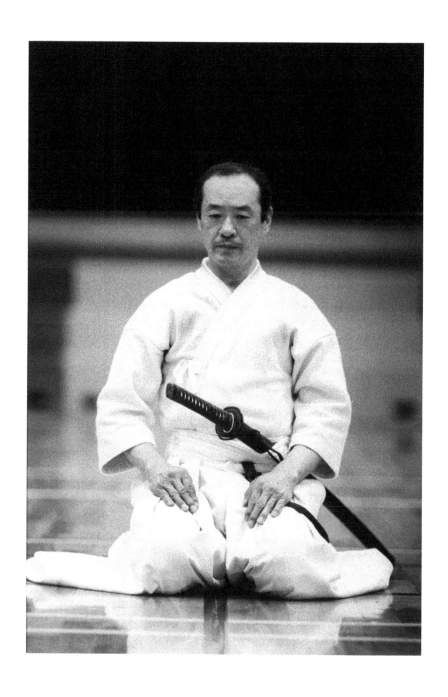

space elements of truth, original work, and expressions of humanity.

We all are explorers. Why should we turn our heads away from light and real experiences? To simulate an utopic freedom? Is a real fracture worth a spectacular illusion? I don't know where my path will end. Maybe freedom is in another space or in another life; in the meantime, I look into what I can face with all my resources and I search for clues in the ordinary before turning my attention to the spectacular. I want to "know myself" and I accept that I can do it only by interacting with the world; I don't see any knowledge in dissociation. The glitz of wish-graphs is not progress; we are piling up new releases of the same virtual game and we are losing real knowledge. It's about time we revise our method.

Photography is in danger. It is in danger because freedom is fragile. Both photography and freedom demand the fatigue of honesty while relating to the overwhelming uncertainty of uncut reality. As with freedom, photography is threatened by epic enemies, fanaticism, fear, lack of reflection, excess of information, and superstition. I ask you to treat what is happening in the visual world with the same seriousness you treat the infringement of other freedoms. Photography is an opportunity to learn from undivided reality. A single photograph is not a language we should master, it is not representing or simulating something. It is the physical emanation of a real interaction; it is an existential record. For this reason, since its birth, photography has challenged our most delicate cord: our immediate relationship with reality. A photograph raises an alarming flag to the status quo

of our powers and our beliefs. It is straightforward, revealing of the flesh and the soul, and formidably self-explanatory. Resolutely, photography demands of humanity, not just our visions.

As a photographer, I choose to explore the connections among my instinct, my soul, my reason, my emotions, my senses, and nature by respecting light. That's my path. My suggestion to fellow passionate photographers is to dispose of their monitors and spend time observing light. Have no fear, there is no such thing as bad light; only vague or ambivalent photographers.

Part Two

Exploring

VI

Controlled Observation

It is a sunny, clear day. I am standing on a smooth cliff overlooking a peaceful lagoon. The water is so transparent that I can see tropical fish and their shadows on the sandy sea bed below. I jump into the water and open my eyes beneath the surface. Not a fish. Can I conclude there aren't any fish? Of course not. I can only conclude I don't see any. Maybe they went somewhere else, or maybe they are behind me. I swim back to the cliff, mulling over a different approach. This time I don't jump. I submerge myself slowly, taking time to feel the different pressure of water and air on my body. This time I find plenty of fish around me. They are still suspicious, but I can see them.

Divers and photographers must share a common conduct. They both realize that in an alien realm what is needed is a relationship based on knowledge, not a solo show. Once

this insight is acknowledged, the correct conduct comes easily. It is sensible to respect the realm we enter, to be in charge of starting a relationship and to be calm in the presence of uncertainty. The necessary condition for divers is to breathe continuously and calmly. Photographers should practice the very same.

My analogy of a diver's conduct has the purpose of focusing our attention on the unique dynamic of exploration allowed by photography. It allows us to follow and be adherent to an evolving reality till the very last moment. Indeed, there are decisions involved: which environment? Which angle? Which point of view? In time, all these decisions come swiftly and follow through the photographer's identity. Above and beyond technical decisions, a photographer must decide how best to relate with his or her environment. Which conduct is required? Does the situation call for control or for spontaneous interaction? In this chapter and in the next one, I will describe two different approaches: *controlled observation* and *dynamic resonance*.

Engineers provide us with a good example of controlled observation. For instance, engineers must have a relationship of focus with the environment, one that involves understanding, creativity, and performance. Further, in order to accomplish their goals engineers choose phases of action. If a bridge is their goal, they create a model of it and simulate its environment. Then they set up a safe experiment in order to test the model. If testing fails, they realize their knowledge is incomplete. In turn, they must review the model. The model is their tool, the interaction with reality is made of forces, the bridge is their creation. This approach is grounded in the use of a method. As Descartes points out, by dividing problems into smaller

entities and solving each entity individually, one is able to understand the greater overall complexity.* This is how engineers observe and control.

Another example of controlled observation can be found in the realm of art. An artist like Caravaggio, in spite of his passionate temper, would also follow a method. He would ask models to represent a scene for his paintings. Through the observation of a human body, alive and bound on a wooden cross, he would paint the *Crucifixion of Saint Peter.*[†] As a result of this method he was able to observe, interpret, and perform. From a dynamic point of view the action of this experience is similar to the activity of our engineer. Caravaggio didn't have to face the responsibilities of a structural engineer, but I am confident that he was just as unforgiving in his artistic fire. I suppose that his ultimate goal was to let his brilliance free by merging his life with paint on canvas. "He simply stood up to the canvas and painted directly onto it, from the living model," writes Paul Johnson, in *Art: A New History.*[‡]

These examples belong to human activities which have existed since the birth of mankind. Learning and performing in this way is also possible for the photographer. The difficulty (the unique opportunity, according to the approach of dynamic resonance), for a photographer, is that he or she is dealing with reality directly and continuously until the final instant.

* Descartes, René. *Discourse on Method and Related Writings.* London: Penguin Books, 2003.

† See Caravaggio's *Crucifixion of Saint Peter,* Cerasi Chapel, Santa Maria del Popolo, Rome.

‡ Johnson, Paul. *Art: A New History.* New York: Harper Collins, 2003.

In photography's realm, controlled observation is my definition for a method that is used when we desire to convey an idea with a photograph. In this case, the concept comes first. The photograph reproduced in the next page is an example of how controlled observation allowed me to reach my goal in a fashion editorial. This particular editorial was about accessories and my purpose was to express the ambiguity that fashion items, when worn as symbols, often suggest to me. Playing with symbols is not appealing to me, but I am curious for the reason behind fetishism. When the fashion editor showed me this bag, the material reminded me of the crocodile at the museum. Then I made the connection that the bag is free to travel, while its source is trapped. I decided to take the bag and our model to the museum. I placed the bag on the glass while the fashion editor was choosing the sunglasses. Once the model was ready I asked her to walk to the wall behind the exhibit. I observed she was too small in the frame, so I asked her to come closer and I found my photograph. The whole experience lasted a few minutes total.

I never asked the model to move or behave in a way that would interfere with the atmosphere of the museum. Indeed, there was no need to make my point more spectacular. I didn't need to ask the model to lay on the case and dominate the scene. Once I knew that my point about fashion was made, I let the model be free, even in that small space, and I waited for her to do something that prompted my response; I think she interpreted my intention genuinely.

Since I decided to use controlled observation to achieve the expression of my idea, I also decided to set the boundaries

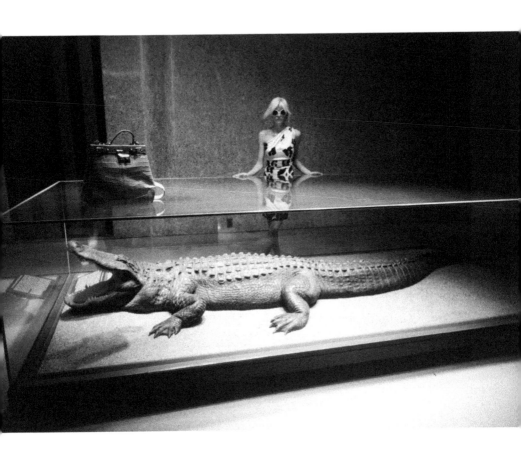

of my control. In this way, my photograph expresses my idea subtly, while revealing the interaction among myself, the model, and fashion.

This example illustrates how I chose to control the environment to express my idea. In every case the extent of such control is a disclosure of the photographer's identity. This is the challenge many photographers face when using controlled observation. We should always remember that we can only photograph the present, the contingent, and that we can't photograph a memory, a dream, or our own imagination. When we cross over from control into coercion, we take away genuineness and what is left is often dull.

VII

Dynamic Resonance

Now it's time to turn our eyes to a different photographic approach. Far, far away from the controlled observation there is dynamic resonance. Dynamic resonance is my definition for the photographer's exploration of freedom. This type of photographic experience is based on the pursuit of knowledge through the understanding of uncut reality—no fiction, no simulation, no safety nets. Grab your camera and photograph the unknown. A road trip with a stranger will do. Wandering at night in the city will, too. Here's the catch: no second chances. There are no rewind buttons or back arrows. It is not an experiment. Next time, the stranger won't be a stranger anymore and the city will charm us with unexpected attractions.

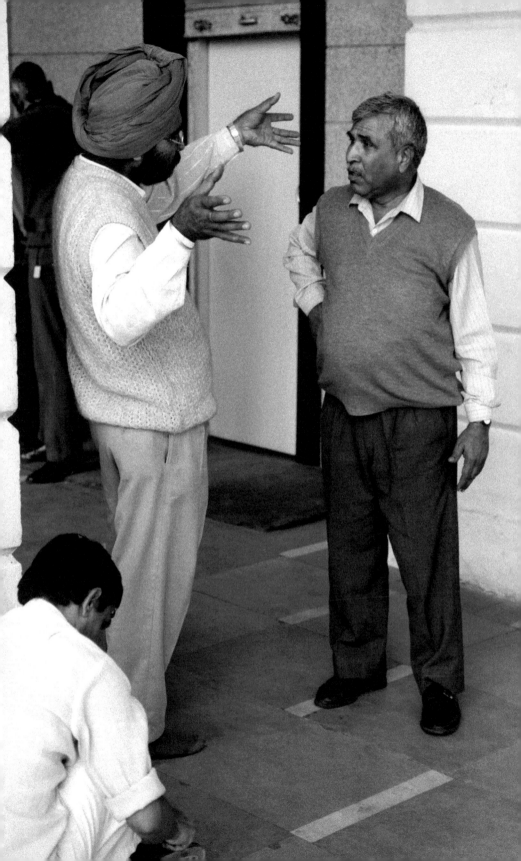

The first time I experienced dynamic resonance was in February of 1995, while in New Delhi on a business trip. On a free afternoon, I grabbed my camera and went photographing in the streets between the Red Fort and the main Mosque. Away from the air conditioned stillness of my hotel, I found myself sweating within a busy crowd where everyone was following his own direction. My mind was focused on the continuous observation of hands, tunics, eyes, turbans, sandals, and scooters. In spite of such turbulence, I was calm. I knew I wasn't in control, but I was highly aware. In that moment, no one gave me reason to feel tense even though I was a stranger. I was simply one of many with a multitude of pursuits. Maybe my appearance helped. Carrying only a camera and an extra lens, I was wearing comfortable clothes, not trying to blend in by wearing a tunic. I was visible and had nothing to hide. I perceived an immediate mutual acceptance, and as a result I was able to observe freely, newly confident in this spirit. In those moments, I learned just how much knowledge could be gained from an alien world. That experience changed the way I looked at photography. Instead of thinking of the camera as a peep hole and the negative as a canvas, I found my grounds for exploration.

This path of exploration needs a continuous focus on our environment, with our mind ready to detect the subtlest signals. It is quite important to remember that such a spontaneous path could turn into a superficial method if there is not both technical and ethical preparation behind it. If we are searching for intimacy we must be prepared to be seen fully. This path is mutual, if we are looking for the soul of our environment then we must be available to reveal

our own. This is why we must master our photographic technique, so that we are able to share ourselves effortlessly. The dynamic of this action is continuous: there are no set-ups. The imperative is to be passionate and genuine, while remaining cool-headed and confident. Here, the click should be the last thing we worry about. First, a relationship must be ignited. Then, once resonance is achieved, our photography will become effortless in this environment. We should see the world as if we were children looking for wonders. We might find many wonders and many photographs, or few. It doesn't matter.

This shooting style should not be seen as a convenient, random or casual encounter, rather as a conscious and full understanding that reality is made of links, links among partners: light, our environment, and our whole identity. Once we raise our flag indicating that we are ready to see and that our intention is knowledge rather than manipulation, we may achieve a valuable encounter. Honest wonder can be a great flag. It can send the right message, showing we are explorers, not spies. Still, if we believe in a space for reciprocal influence, the quest for intimacy shouldn't make us long to be invisible. Otherwise, a surveillance camera could do the job.

Photographing a person is an effective way to experience dynamic resonance because each and every person is an enigma. This allows the photographer to participate in an exchange of free will. My ultimate goal is to create an exchange in which a person feels free from perceived expectations. So, who do I partner with? All I need is to find someone with a spontaneous drive. Models are often associated with the

structured business of fashion, but they can also be accidental acquaintances, with whom we share only a few minutes. Whether I find a muse who works in fashion or the two guys staring at me on the next page, the critical factor is that I need someone willing to be photographed. At times, I was doubtful, even skeptical, about the existence of a partner animated by free will. I was a prisoner of the thought that someone's conduct would derive only from a rational utilitarian motive, an emotional need, or from a trauma. In this I was wrong, very wrong. I got a clearer view about the essence of freedom after shooting thousands of photographic negatives.

Photographers should also be honest with themselves about how the overall environment affects them; for example, how a location promotes freedom from unnecessary noise. Again, knowing ourselves is the key. In my case, I prefer to photograph anywhere other than in a studio. My focus is always more precise in an unpredictable situation. I always opt for a drive to the seaside, an unexpected storm, a sudden detour in the park, a blanket, shallow warm water, the waiting room of a bus station, etc. Ordinary situations are opportunities to form a connection with the models and to observe them talking on the phone with their agents, crying over despotic boyfriends, falling asleep on the car seat, telling me how yoga made all the difference, and asking me about my life. Eventually, the conversation turns to the model's expectations of our shooting. Here it is important to be clear; everyone has expectations, even if they don't think they do. A fashion model may want to challenge the niche she has been pigeon-holed into, while the actress may want to look like a model. Each person brings her own baggage, her own

desires. Some carry their agents', boyfriends' or mothers' baggage with them too.

One model shared that since giving a killer smile to one photographer early in her career, she had only been cast as the "smiley one." She wanted to be sexy. Another model told me the opposite story, "I am fed up with showing off my body in curves, I feel like I am damn snake, can you please take a photograph of me while I am just standing straight?" I usually replied with something like, "My purpose is not one particular expression or pose, and I have no story board. You can move any way you wish. My intention is not to tell a story or to superimpose an iconic image. I would rather challenge you with a quest; you will understand the purpose of this quest once we start." I would stress, "You can start from your desire. You wish to be sexy? A zombie? You desire to jump? It's all fine with me, but let's not get stuck. Feel free, even in the most simple way, like a child. Then you can explore from there."

The point here is that I was asking each person exactly what I expected of myself. My goal was to concentrate on a new experience and ignore any noise from images I recalled. With my mind in a more receptive space, I focused on the person who was in front of me. This was always my goal. Of course, I was not always successful. It is difficult to resist placing a model into a previous image; offering motivation, space, and freedom is much, much harder. But in this way, I could witness the evolution of her freedom as I photographed her talent. I have never had any other ambition than photographing the person who was in front of me. I have never tried to see him or her as a copy, an icon, or an ideal. My goal is to liberate. My quest is to inspire freedom, theirs and mine.

Once, while I was loading my camera, a model asked me "What does natural mean?" I didn't reply at once so she kept on. "My hair is in a pony tail, I have no make up, I am wearing a grey tank top and jeans. So what? I am still a model and you are still a photographer. This is not natural. I say it is fiction. So, what do you say to that?"

I replied, "I say it is natural. I am here because I would like to photograph you and you told me you would like to be photographed by me. The photographs will reveal how our natures react in the present condition. I don't see how being related to you or wearing a shiny birthday crown would make our photographs more or less natural, they would only be different." I focused my lens on her and I kept talking. "I would like to see you without crowns for a while, but later you will be welcome to put on more accessories, if that is your wish. My suggestion is to forget for a moment about accessories and try to enjoy what you do in front of me. If you feel stiff in your bones right now, just look at me and stare at me for a long time. Do what I am doing. Don't worry about what you will do next. Keep it up until it feels natural to you."

After that initial talk, there was no other talking. Her talent was there but she had been worn out by a lot of jobs. I tried to help her ignore her noise by influencing the pace and rhythm of the shooting. Now, with another model or at another time, my words and attitude might have stifled her, but in this case they helped.

Bear in mind, that what is agreed upon in words is not immediately achieved in practice. So before the job of reaching the core of someone else's talent, there is often the work of erasing hideous concerns such as "How should I look?" and

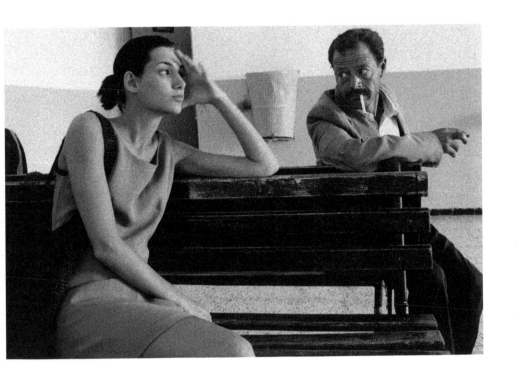

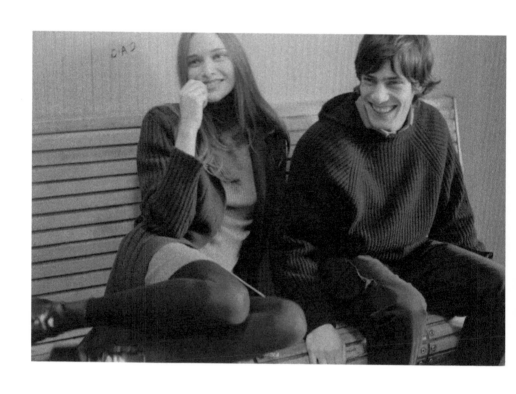

the like. A model, as we all do when it comes to gestures, learns from imitating other models and often repeats what is usually asked of him or her. So you may consider using a few rolls of film in order to make him or her feel comfortable. Further, a break, a change of location, or a swim in the ocean might help to leave the habitual behind. In such a case, there is no manual to guide the photographer, I had to watch for signals and I had to be mindful about timing. One person might not be ready to give up rituals; whereas, someone else may be craving for it. In spite of what people claim, photographing a person is not giving instructions. Instructions are meant for computers and robots. They may help models begin their quest, but are not sufficient to complete it.

Once, I gave my camera to a model in order to help her understand how complicated it was to follow someone's erratic movements with a manual lens. I proposed a short game where we would slow our pace almost to stillness. She loved it and she gained a new consciousness about her body language. On other occasions, a run on the beach helped to loosen up a stiff posture and get a spark—likely prompted by hate— from sleepy eyes.

The conscious effort of observing and reading clues through our environment pays off. After an indefinite period of time, a new state of mind is triggered. The rhythm of the shooting sifts away anxiety, nervousness, and diffidence. These are replaced by confidence and a desire for truth. All the rational, emotional, and traumatic excuses wash away leaving the core motive; an experience of freedom. Prejudice leaves and identity takes over. Then, a new, reciprocal space of interaction is created and everything shifts. The sounds of

the camera's mirror and shutter underline this connection. Now the photographs record reactions to each other's presence. This is the mutual interaction I was explaining when I described dynamic resonance.

So what is the source of this trigger? I think each model slowly realizes how much he or she can learn by pursuing an experience of freedom, taking a chance to explore a deeper level rather than hanging on to glamour or exhibition. My conduct and the conduct of each model determined our level of discovery. Our body language, words, voices, pauses, enthusiasm, and honesty are recorded in my photographs. So again, the key element is freedom achieved through interaction. This freedom, experienced intellectually, emotionally, and instinctually, results in an accumulation of knowledge which enlightens my understanding of free will.

I believe that the experience of free will is something that conceptual methods can't fully express, whether they are built on words, numbers, or symbols. Free will is deeply rooted within life as a whole. Free will is a conduct. It is letting my identity emerge from noise, make decisions, and reveal its essence while driving my emotional and intellectual faculties in the pursuit of knowledge. Photography is a peerless enterprise because it helps to access this consciousness. This is what happened to me in New Delhi: it was my conduct (the expression of my whole identity), not just my angle (a visual point of view), that opened the doors to what I was able to see.

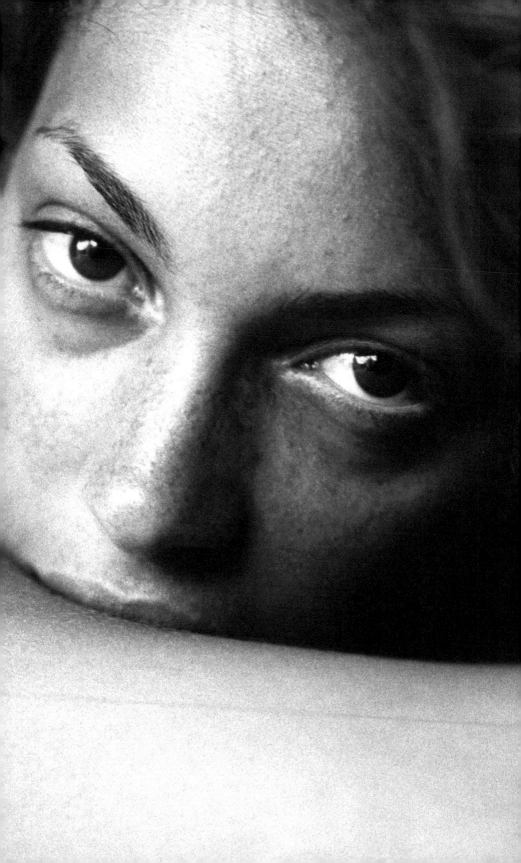

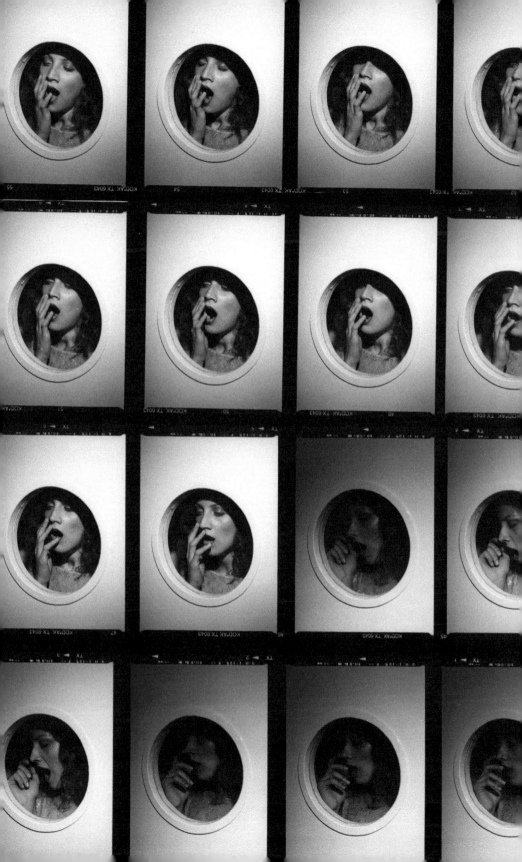

Epilogue

On a dreary day the King summoned the Explorer and told her, "Everybody is getting depressed in my kingdom, most of all Lady Crowd. You know how vital she is; she is the spirit, the avant-garde of my kingdom. I need Lady Crowd thrilled, I want her energy back; she is a reference for the masses. I want my people reassured, happy, free from annoying thoughts, and able to feed my greed with more conviction. If I don't take immediate measures I know I will loose my kingdom. The Artist is not a loyal courtesan anymore, he has lost his edge. He says he is bored with portraying me. He talks only about his need

for emancipation from my figure and my cause. I suspect he loathes anything except himself. He is forgetting who made him who he is. Before I chop his head off, bring me some marvel I can use to replace his. Otherwise, your head will fall."

The Explorer headed home thinking, "Kings. They are all the same. They always threaten with the mention of heads, yet they wonder why people sometimes are willing to take their heads." After some time, she returned to the palace with a device that looked like a box and asked the King to mount his horse and ride. Later that day, she showed the King a photograph. The King was amazed at first, and asked the Explorer to explain her wonderful magic. The King adored magic. Magic was the official religion of the Kingdom of Denial.

The Explorer explained to the King that there was no magic involved in her discovery, quite the opposite. "A photograph is a document recorded by light and matter. This invention is not a product of imagination or memory. The photograph is evidence of the King's presence in front of me." The King didn't understand because he was busy looking at the photograph as he would have looked at a painting. He was also furious. "Your photograph is a menace to my kingdom. In every novel, play, billboard, statue and painting, I ride a white horse. The horse in your photograph is grey. So, so depressing. Even worse, I look chubby and my nose shows my passion for alcohol. My eyes! Oh my eyes! They look like the eyes of a child. You are a disgrace. Do you want Lady Crowd and my people to laugh at their King?"

"Sire," replied the Explorer, "to use this invention you

need to understand it first. One photograph cannot grasp the entirety of reality, but is founded in physical reality. It is a trace, not a wish. The reason why Lady Crowd is getting depressed is because she doesn't believe anymore that you only ride white horses. Some of your people even question your existence. You gave me an assignment and I am giving you my solution. This is proof that you exist and that your appearance is not so different from your people. There is nothing wrong with being a little robust. Lady Crowd and your people would be stupid to judge their King by the size of his belly or the color of his horse. Still, the reason why your eyes are vulnerable is my fault. You see, a photograph takes team work. Out of all the looks you gave me on your horse I responded to this particular one. Click! I followed my instinct. I didn't think about the assignment. Anyhow, if you find a white horse, stop eating like a wild boar, and stop drinking, I might be able to find a photograph you end up liking."

"Your insolence matches your ignorance about power," the King whispered. "Lady Crowd and my people are what they are precisely because they see what they wish, not what is in front of them." The King's eyes were shining greed. "My dear girl, the only reason why your head is still on your shoulders, besides your amusing lack of malice and inability to compete with me, is because I am interested in one word out of the many nonsensical words you have mentioned. Proof. I find this word fascinating! Leave now, and bring me some more proof as you see it. Your pick. Then, I will summon the Artist and give him a chance to keep his life."

The Explorer left the palace with adrenaline pumping through her body and a frantic wonder knocking in her head. She was still alive in spite of her daring attitude towards her King. Where was that courage coming from? Still puzzled she dropped that question since she was getting more and more curious about the one word she had used. It was not the word "proof", the word the that the King had found fascinating. She was clear about that aspect of a photograph, as she was also clear about the intention of the King to manipulate, an old game that had been going on since the birth of Kings and Explorers. No, the word was "instinct." She had said, "I followed my instinct." She was no longer afraid. She had found a new quest.

To be continued.

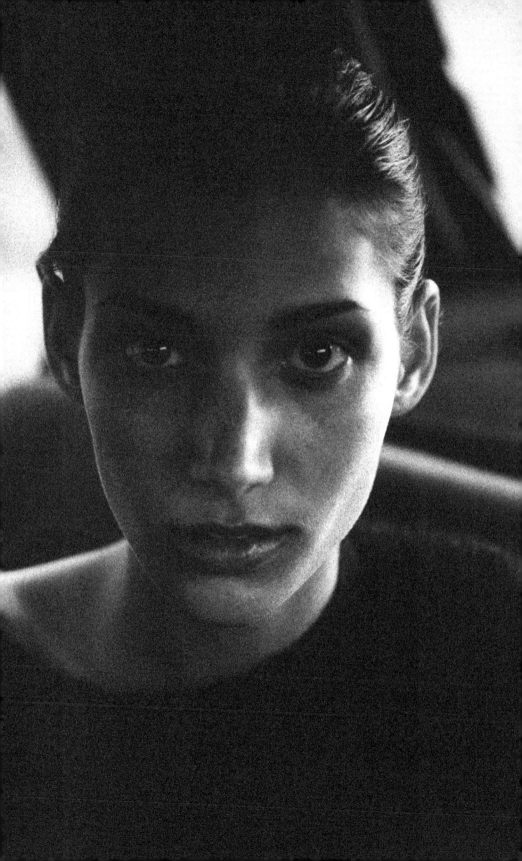

Acknowledgments

I would like to thank those who helped me by sharing their knowledge, their time, and their passion. Joyce McDonough patiently improved everything I submitted to her, from my initial draft to my final manuscript. She made me aware of the power of words and the value of clarity. She turned an improvised writer into an enthusiast of the English language.

John McDonough, an avid reader and a passionate teacher, helped me to straighten my storytelling. Thank you John, you were right from the beginning.

My best friend, H. Jost Reinhold, while playing golf in his living room, challenged me on the critical arguments presented in the first chapter. His unique blend of critical thinking, humor, and style has always been a profound source of inspiration in my work.

Michael Denneny agreed to edit my manuscript; this was pivotal for my book. While debating with his brilliant mind and observing his quiet charm, I strengthened my resolution to publish this book.

Giovanni Azzone, a true friend, gave up some of his few moments of rest from great responsibility to reassure me with the authority of his logic. Andrew Epstein supported me and consistently encouraged me.

Deborah Daly refined my raw design and developed my mockup into a book. As a photographer, I wish I had the pleasure of working with an art director like Deborah sooner.

My wife Michelle deserves my deepest gratitude. She spent countless nights reviewing my work, challenging my ideas, and suggesting precise words to a stubborn husband. She helped me to see coherently into my heart and my mind, and she never let her talent overshadow my work. Thank you, my love.